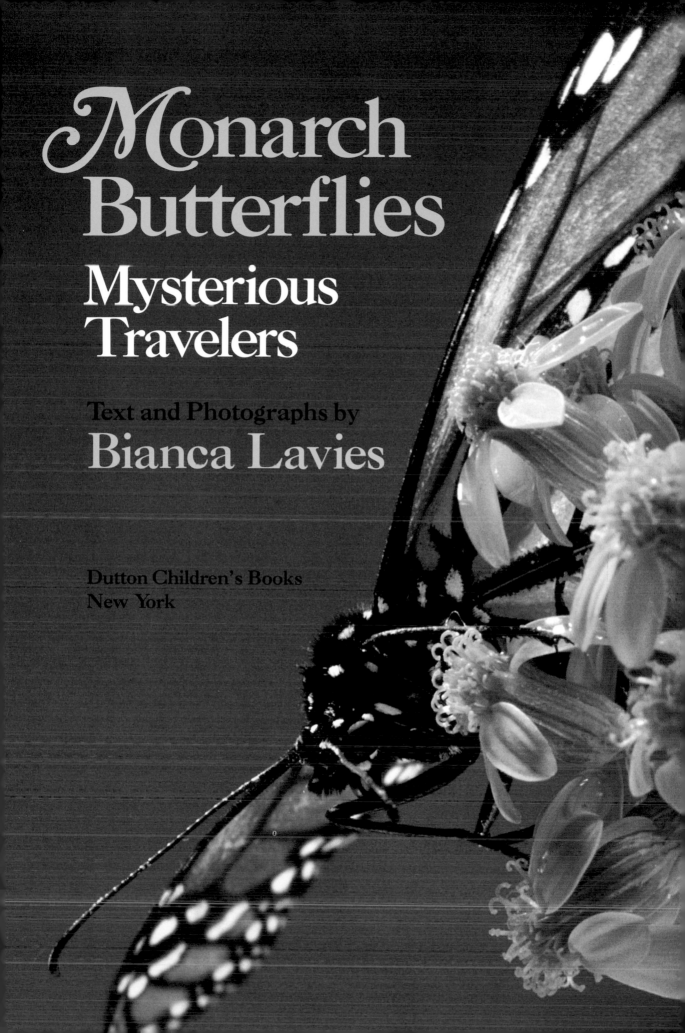

# Monarch Butterflies
## Mysterious Travelers

Text and Photographs by
### Bianca Lavies

Dutton Children's Books
New York

This book is dedicated to Dr. Fred Urquhart and Norah
Urquhart for their lifetime study of this fascinating butterfly;
to my fellow travelers and friends Cathy and Ken Brugger;
and to their dog, Kola, always a tireless leader on our hikes to
the overwintering sites.

ACKNOWLEDGMENTS
For sharing time and knowledge the author wishes to thank
Robert T. Mitchell, a wildlife biologist formerly of the Patuxent
Wildlife Research Center and the author of *Butterflies and Moths*
(Golden Press); and Ken and Cathy Brugger, research assistants.

*Library of Congress Cataloging-in-Publication Data*

Lavies, Bianca.
Monarch butterflies: mysterious travelers /
text and photographs by Bianca Lavies. — 1st ed.
p.   cm.
Summary: Text and photographs describe
the physical characteristics, life cycle, migration,
and study of monarch butterflies.
ISBN 0-525-44905-1
1. Monarch butterfly — Juvenile literature.
2. Monarch butterfly — Pictorial works — Juvenile literature.
[1. Monarch butterfly.   2. Butterflies.]   I. Title.
QL561.D3L38  1992   595.78′9—dc20   92-28337   CIP   AC

Published in the United States 1992 by
Dutton Children's Books,
a division of Penguin Books USA Inc.
375 Hudson Street, New York, New York 10014

Designed by Sylvia Frezzolini

Printed in U.S.A.      First edition

10   9   8   7   6   5   4   3   2   1

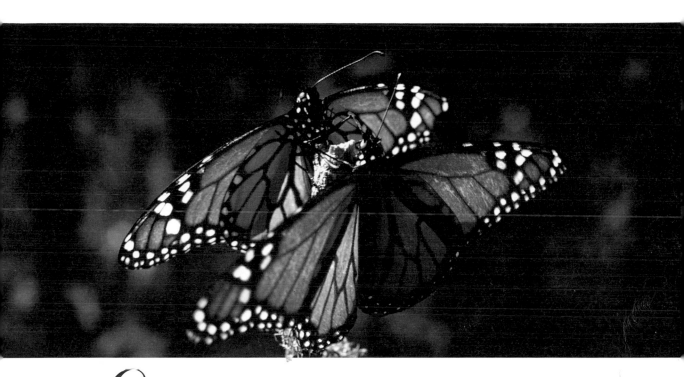

*L*ook carefully at the brilliant orange-and-black wings of these adult monarch butterflies. How translucent they are against the light. And how seemingly frail. Tiny scales, which brush off in the hand like dust, give the wings their iridescent color.

How is it possible for such delicate insects to fly thousands of miles south in migration? Yet every autumn millions do, even embarking on a return trip north. Other butterflies migrate, but the monarch is the only butterfly that makes a round-trip.

In summer monarchs are found over much of the continental United States and parts of southern Canada. But where do they go to avoid the killing frosts of winter? Is it to the same place every year? For decades one scientist sought answers to such questions. This is the story of how he solved part of the mystery of these enchanting, fragile travelers.

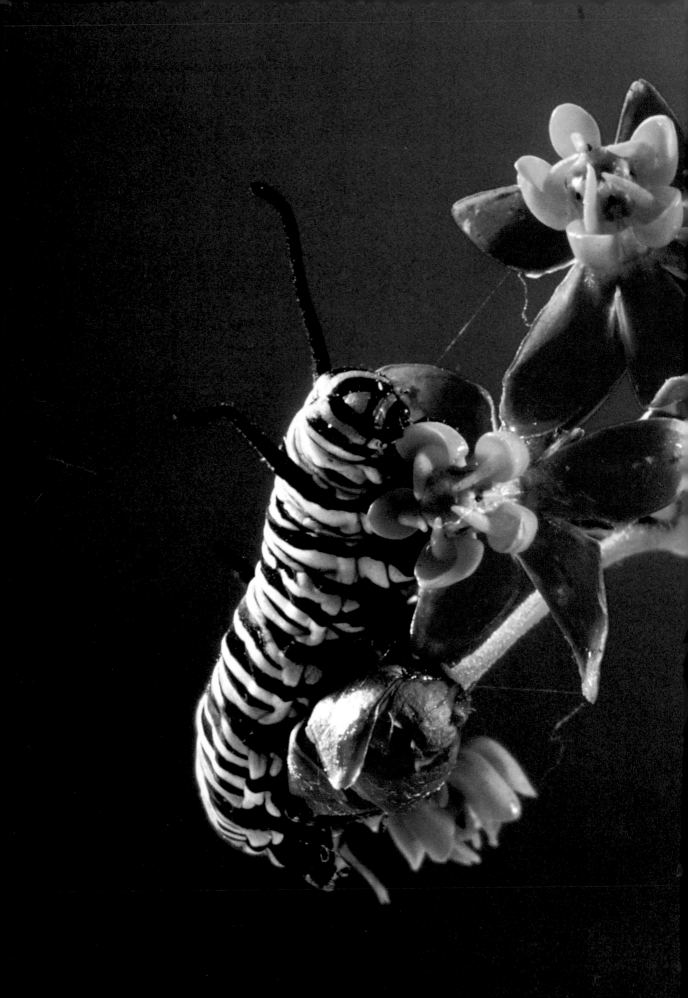

Ever since it hatched from a tiny egg two weeks ago, this caterpillar has done nothing but eat and rest and eat again. First it devoured its egg case. Then the caterpillar turned its strong jaws on the milkweed plant where its mother, a monarch butterfly, had laid her eggs. Milkweed leaves are the only food monarch caterpillars eat.

The caterpillar is one stage of the monarch life cycle from egg to adult butterfly. Another name for the caterpillar is larva.

This monarch larva grew so fast that every three or four days it had to shed its skin, or molt. A new layer of skin, bigger and brighter each time, was right there under the old one. After four molts the caterpillar is two inches long, full grown. Very soon it will stop eating and seek a shaded, sheltered spot to begin the next stage of its life.

To the underside of a twig the caterpillar attached a wad of silk, spun from a gland near its mouth. To this it fastened another little pad, or button, of silk. Then it grasped the silk button with its hind legs and hung upside down for between twelve and nineteen hours. Finally, stretching and pulsating, the caterpillar shed its skin for the last time.

The result of this final molt is the beautiful pale green chrysalis pictured here—something no longer a caterpillar but not yet a butterfly.

At first the chrysalis is soft and damp. But as it dries in the air, it stiffens, turning the color of jade. Inside, cells begin to grow and multiply, replacing fleshy caterpillar features with the slender body and graceful wings of an adult butterfly. During this metamorphosis, or change of form, the insect (called a pupa) does not eat or drink.

Notice the sparkling gold spots. The word *chrysalis* comes from the Greek word *chrysos,* meaning "gold." Some scientists believe the spots control color in the developing wings.

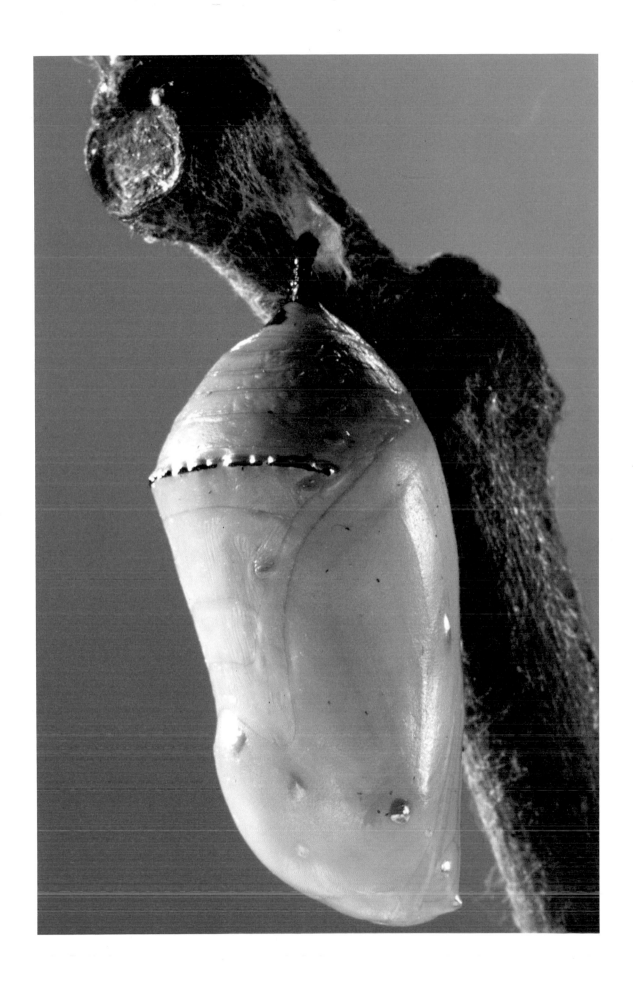

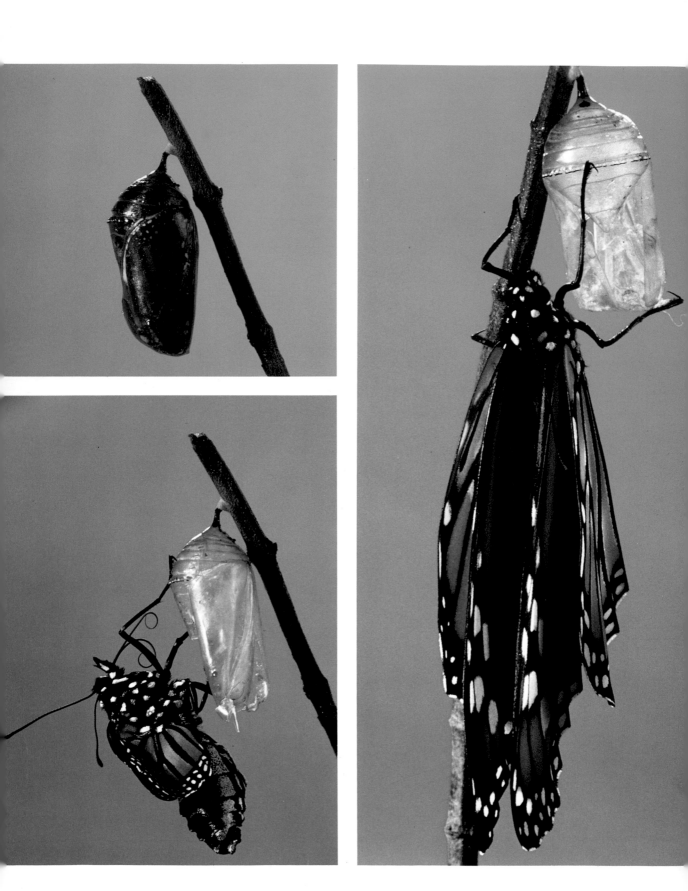

During pupation, which takes from nine to fifteen days, depending on the temperature, the chrysalis changes from blue-green to dark gray. Just before the insect hatches, the outer shell becomes so clear that the orange-and-black pattern of the adult butterfly's wings shows through.

Somehow, newly formed monarchs can sense weather conditions from inside their chrysalises; they rarely emerge except on warm, sunny days. The clear chrysalis case cracks, and the adult butterfly pushes out. Hanging on to the case, it pumps blood from its body into hollow spaces between the two parallel membranes of each wing.

As the wings expand, the monarch opens and closes them in the drying sunlight and air. Two hours may pass before the wings are firm enough for flight. During this time the monarch clings tightly to its case. A fall could damage its wings or expose it to attacks from mice, shrews, or ants.

When the wings are stiff and strong, the butterfly is ready. In the warm sun, it takes off with a quiet swoosh to search for its first adult meal.

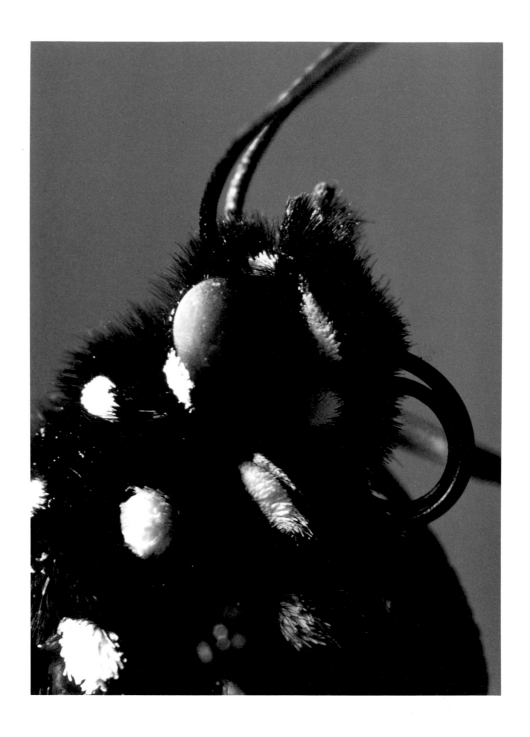

The adult monarch no longer has the caterpillar's
chewing mouth parts, nor does it eat leaves. Instead, it has
a hollow drinking tube called a proboscis, which it uses like
a straw to suck nectar from deep inside flowers. When the

butterfly first emerges from its chrysalis, it coils and uncoils the two halves of its proboscis to zip them into one long sucking tube. The proboscis tucks neatly away under the monarch's head when not in use.

Taste sensors on the butterfly's feet and smell receptors on the surface of the antennae help the monarch find and identify its food.

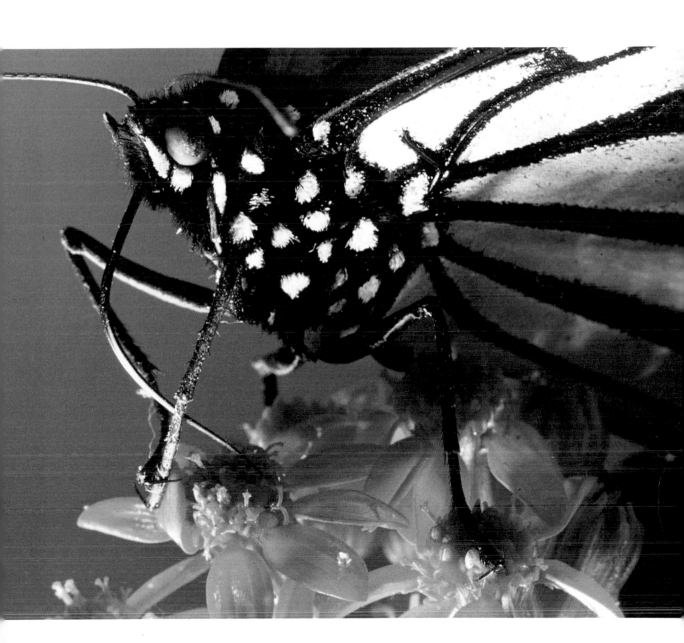

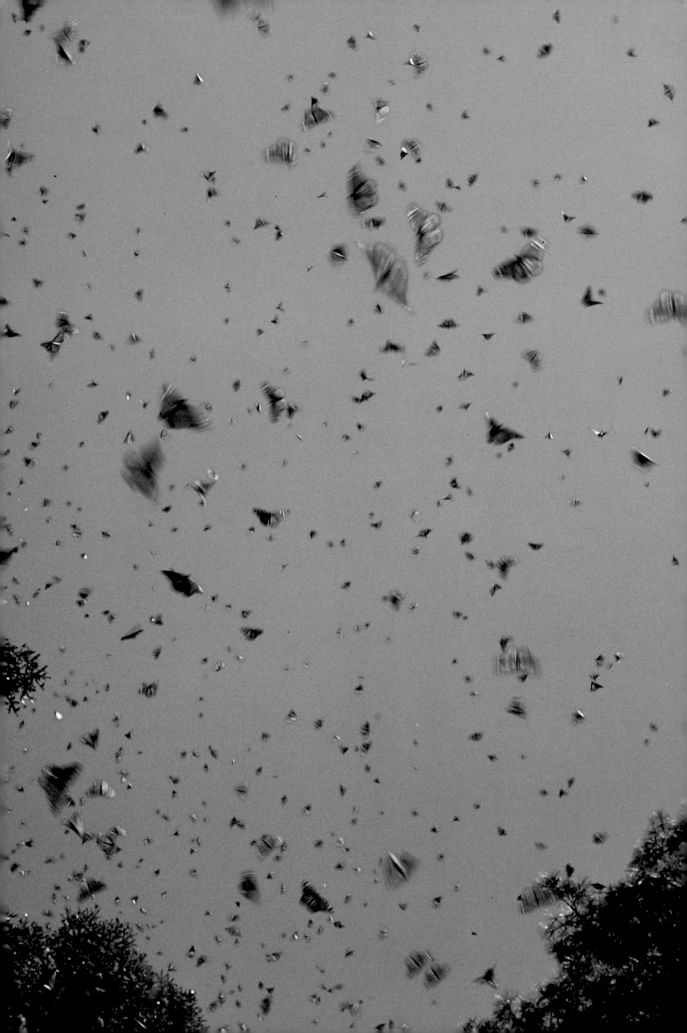

Monarchs that emerge in spring and early summer mate within about four days. Then the females busy themselves laying creamy yellow eggs on milkweed plants, sipping nectar from flowers, and drinking water from streams and puddles. A month or so later, both males and females die; in the meantime, a new generation of caterpillars is on its way to becoming butterflies.

Monarchs that emerge in late summer and autumn, however, lead longer, more far-reaching lives. The shorter, cooler days of early fall postpone the development of their reproductive organs. This, plus changes in light and temperature, perhaps along with other factors not yet understood, cues these monarchs to take to the skies, migrating hundreds or even thousands of miles across the continent to warmer wintering grounds.

They are strong, fast fliers, reaching speeds of ten to thirty miles per hour. Along the way, they sip from nourishing plants, fattening themselves for the coming winter. Monarchs are unable to fly when the temperature drops below fifty-five degrees Fahrenheit, so at night they roost on trees or bushes, then continue on during the warmer daytime.

People often wondered about the fluttering monarchs that filled the skies or clustered together on trees—usually the same trees year after year—from August to October. Researchers believed that monarchs west of the Rocky Mountains migrated to the coast of California. But where did the eastern monarchs go?

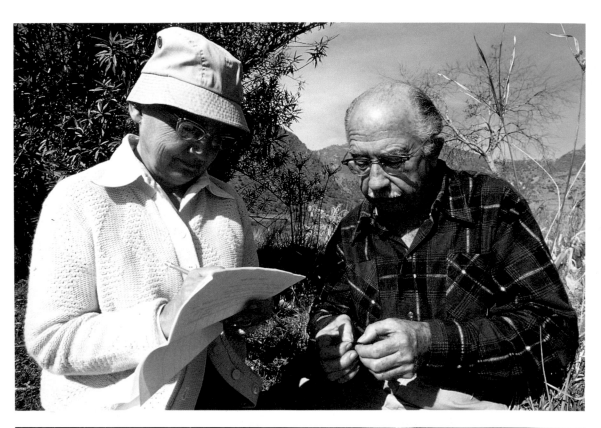

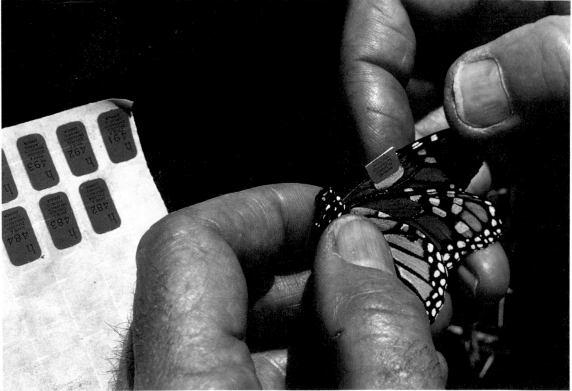

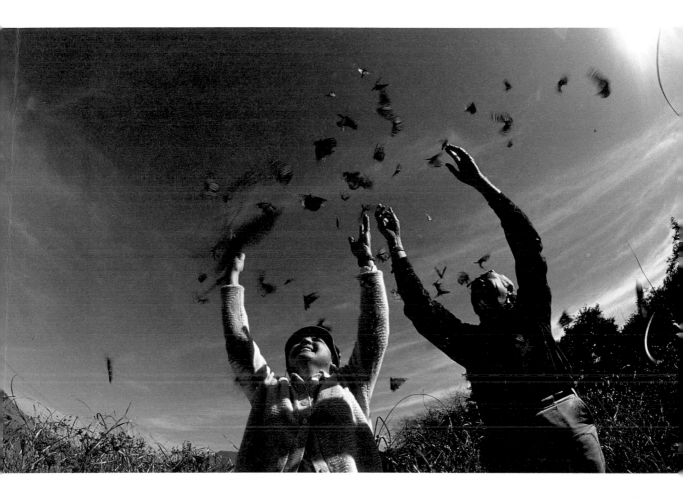

Since 1937, Dr. Fred Urquhart had been trying to discover where the eastern monarchs spent their winters. He and Norah, his wife and research assistant, tagged thousands of monarchs with labels that did not impede flight. Each tag carried a number and a request to mail it to the University of Toronto, where Dr. Urquhart worked.

Eventually children and adult volunteers all over North America helped with the tagging and also reported information about labeled monarchs they found. A picture began to emerge: Most monarchs that crossed the eastern United States seemed headed for Mexico.

Norah Urquhart wrote to newspapers in Mexico, asking people there to report sightings and help with tagging.

An American named Ken Brugger wrote back from Mexico City, offering to look for monarchs as he traveled the country with his dog, Kola, in his motor home. Shortly thereafter he married Cathy, a Mexican woman. She was a great help in the search because she could question local villagers in Spanish.

Ken, Cathy, and Kola—often with a guide—spent months following steep trails in the Sierra Madre Mountains. After about a year of searching, they were trekking up a two-mile-high peak in the early morning when they noticed a few monarchs circling downward. Local woodcutters had told them of swarms of butterflies nearby. Sure enough, a little higher, the ground proved littered with monarch wings—a sign that mice, birds, and other predators had been at work.

Near the summit, the trail of broken wings veered off into a dark forest of oyamels, local fir trees. At first glimpse, it seemed the trees were clothed in layers of dead brownish black leaves. But as sunlight pierced the dense evergreen forest, Cathy and Ken saw flashes of brilliant orange. They were looking at tens of millions of monarch butterflies hanging from tree trunks and branches, and covering the ground like a thick carpet, wings closed in the cool morning air. The first monarch overwintering site in central Mexico had finally been found by researchers.

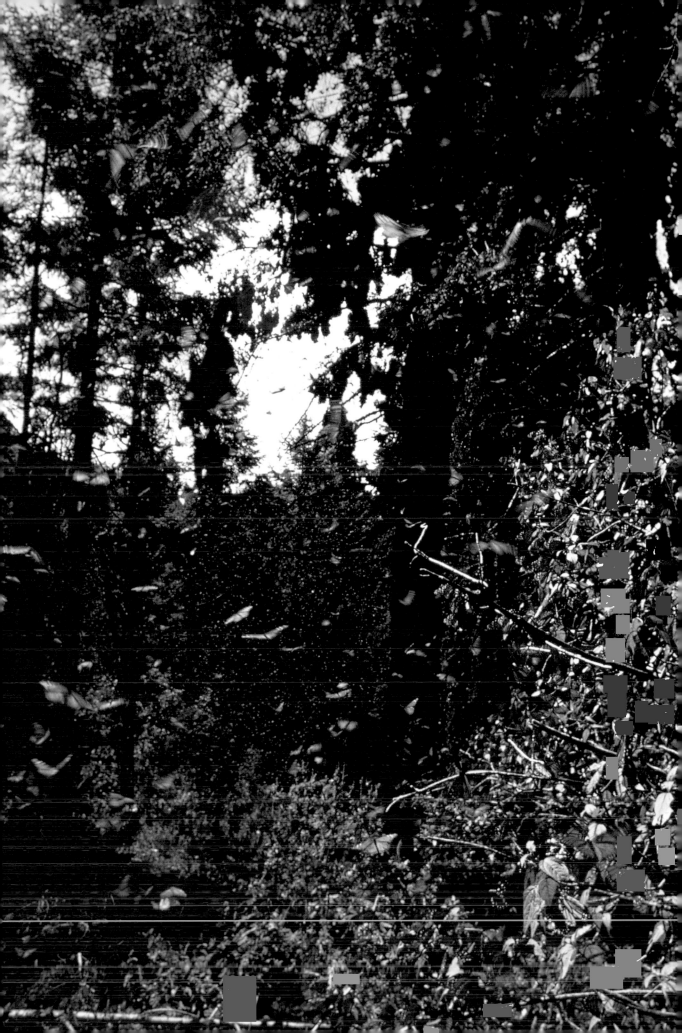

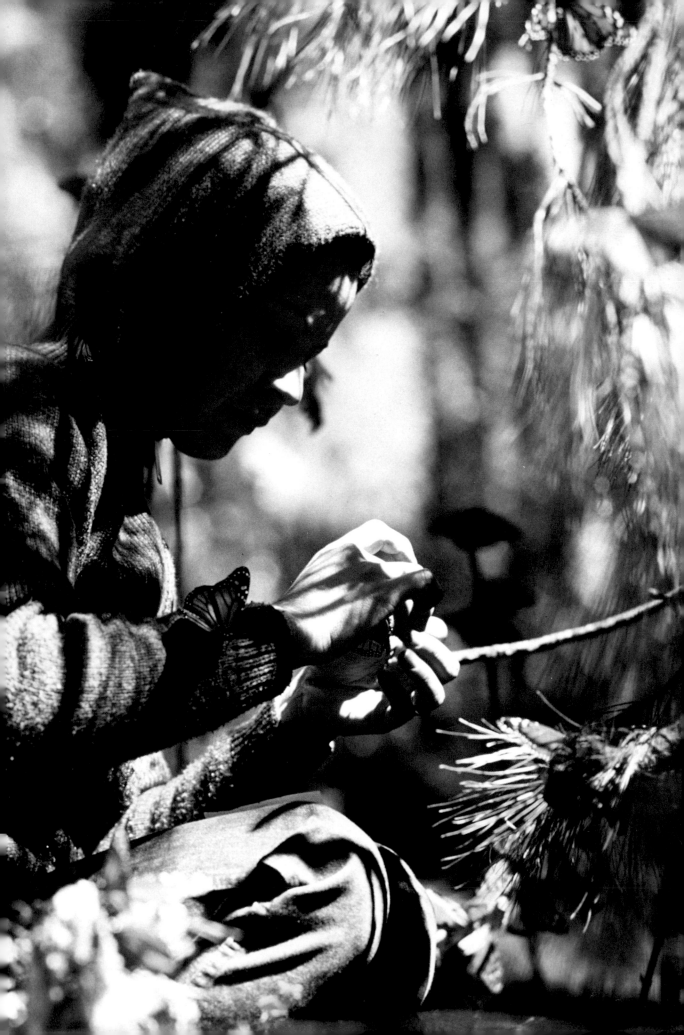

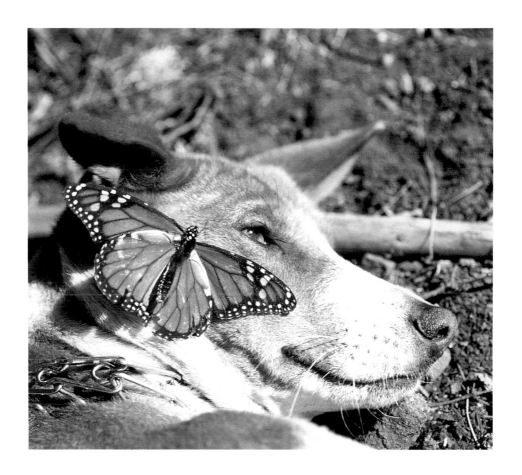

The Bruggers hurried to share the good news with the Urquharts in Canada. While waiting for them to arrange a trip down, Cathy and Ken worked every day, tagging butterflies in order to learn more about the northward migration to come. They also found more than half of the dozen or so overwintering sites that were eventually documented within a three-hundred-square-mile radius.

Some of the butterflies, like the one that has settled on Kola *(above),* showed the wear and tear of their arduous journey. The spot on each hind wing—dark scales covering a scent pouch for attracting females—identifies this one as male.

At last the Urquharts arrived in Mexico City. Together with the Bruggers and photographer Bianca Lavies, they drove one hundred and fifty miles west into the mountains. Their rented bus wheezed and sputtered as it climbed seven thousand feet over rough, twisting roads to a small hotel surrounded by hundreds of white and red geraniums.

The next morning they drove farther up the mountain, winding through villages of simple homes gaily decorated with flowering plants. In one village they picked up their guide, Juan Sanchez *(right)*. After an hour and a half the road ended, and they drove on over a flat mountain plateau. Finally they parked the bus and continued on foot, Kola always by their side.

For the next two hours they climbed a steep path, until, at ninety-eight hundred feet, they came upon a forest of tall oyamel trees. The Urquharts stared up in amazement, tears in their eyes. Here before them was the reality—astonishing and beautiful to behold—that had been the hope of a lifetime's research and hard work.

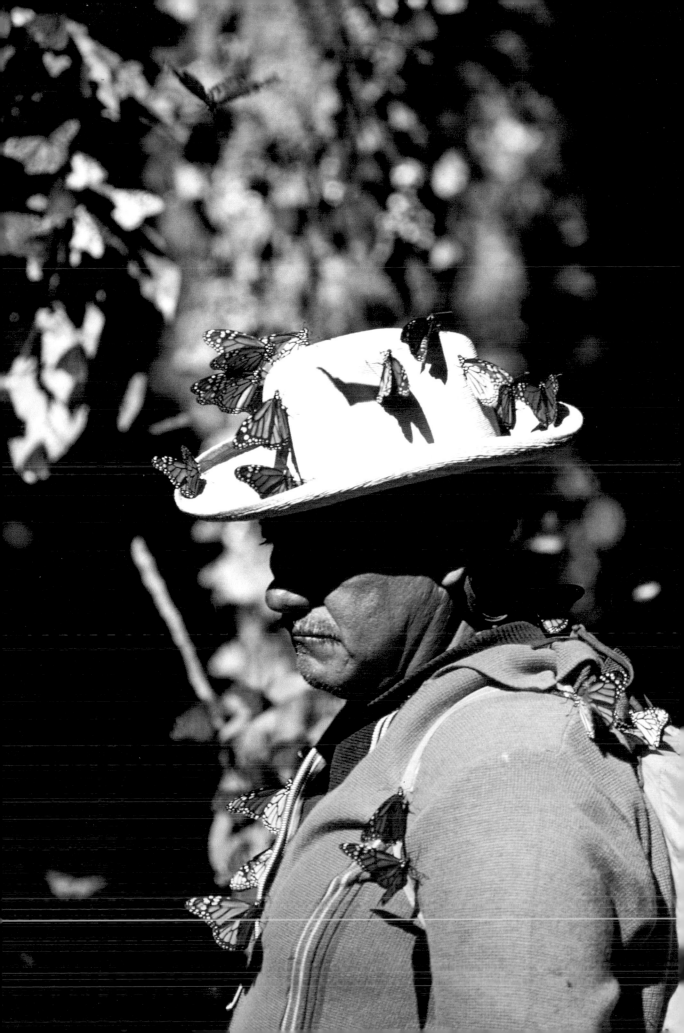

Everywhere they looked, butterflies blanketed the ground and hung from branches and tree trunks, their wings held closely together. Each time a ray of sunlight reached the butterflies, they fluttered into the sky, rising above the trees like puffs of orange-and-black smoke.

Monarchs have no internal heating system. They rely on the sun to warm them. In order not to overheat, they spread their four-inch wings and fly. By alternately basking to gain heat and flying to shed it, they regulate their body temperature. The oyamel forest high in the mountains was generally cool enough for them to remain dormant—a resting state in which little nourishment is needed—but not so cold that they would freeze.

The monarchs hook their feet onto the needles and bark of the oyamels and rest securely, side by side. The thick forest growth offers shade on sunny days, keeps the temperature from falling too low at night, and provides shelter during storms.

Sometimes the clusters of monarchs get too heavy...

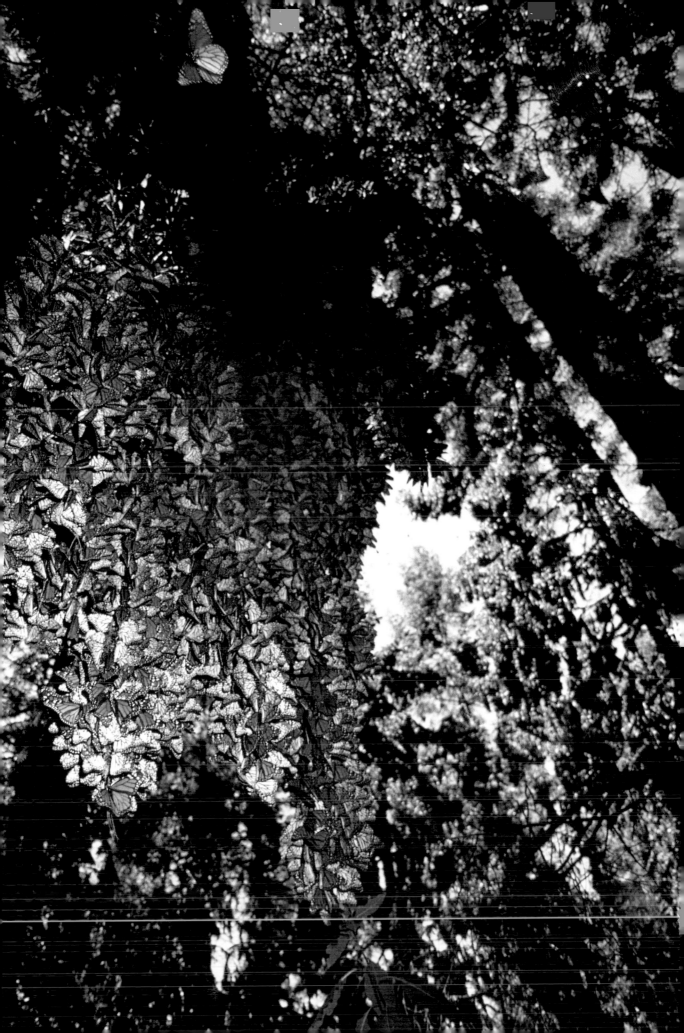

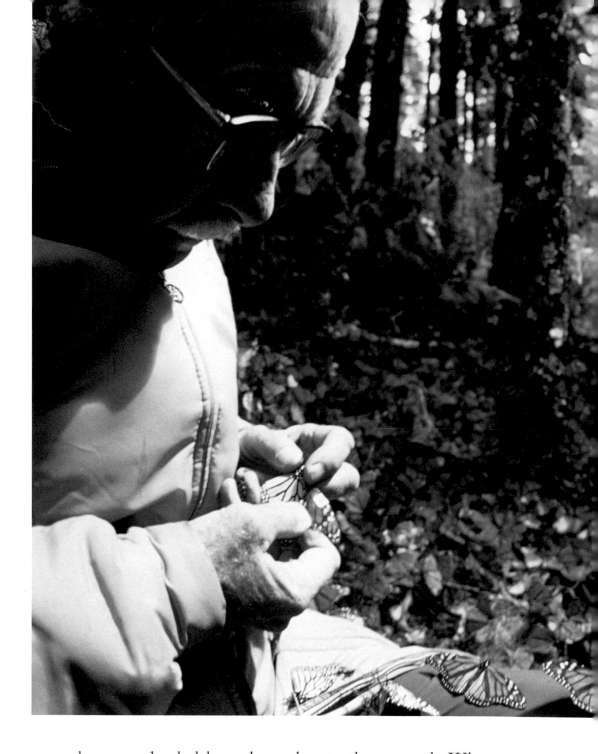

...and an overloaded branch crashes to the ground. When
Dr. Urquhart sat down to have his picture taken in the
middle of just such a fallen pile of monarchs, with great
good fortune his eye came to rest upon a butterfly bearing
a white tag.

The tag enabled him to trace the butterfly back to
Chaska, Minnesota, where, four months earlier, a teacher

and his students had marked it. Traveling two thousand miles over mountains and rivers, congested cities and wide-open spaces, this featherweight flier had journeyed to the very stand of oyamels where its great-grandparents had probably overwintered—and where its great-grandchildren would, in all likelihood, arrive next year.

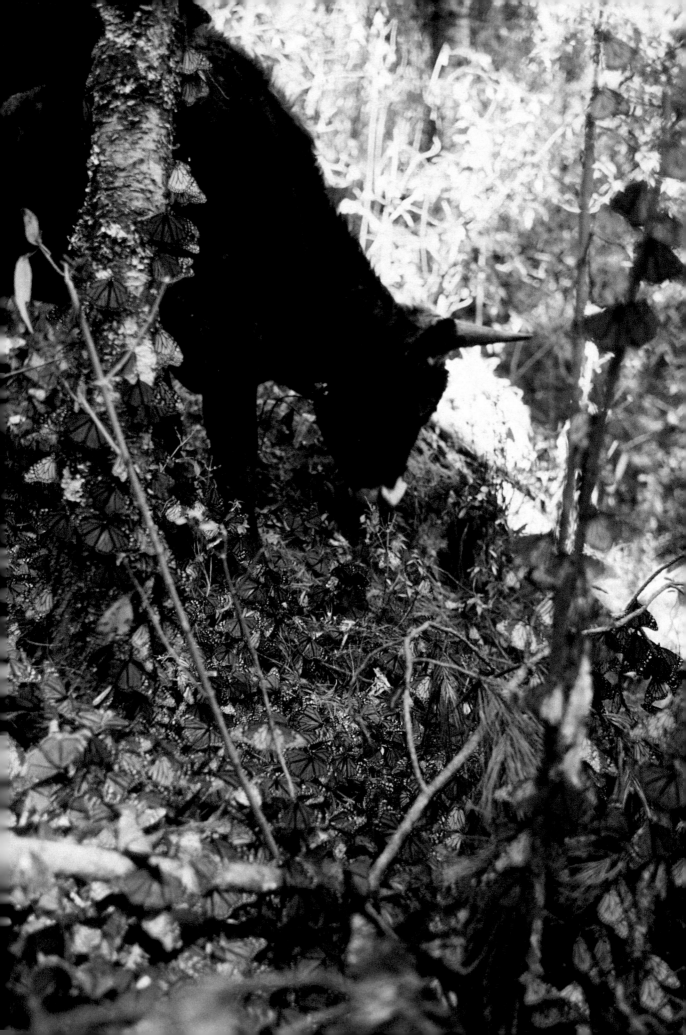

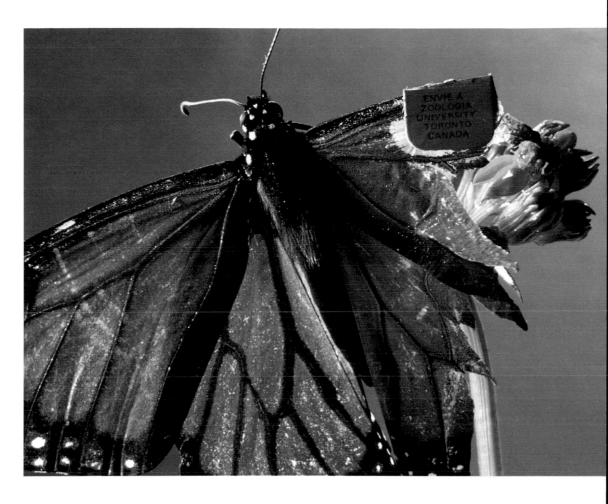

While the Urquharts and Bruggers were busy tagging, crackling twigs more often than not announced the arrival of cows plodding through the brush. They trampled the thick carpet of butterflies, sucking them up by the dozens with large circular sweeps of their tongues. A local farmer told Cathy Brugger that his cows got fat during the winter from eating so many monarchs.

In the chill dawn air, when the butterflies were too cold to move, birds were also a menace. The birds picked them off the upper branches, stood on the monarchs' wings, and ate their fleshy abdomens. Butterflies with torn wings, broken antennae, and missing legs were common findings.

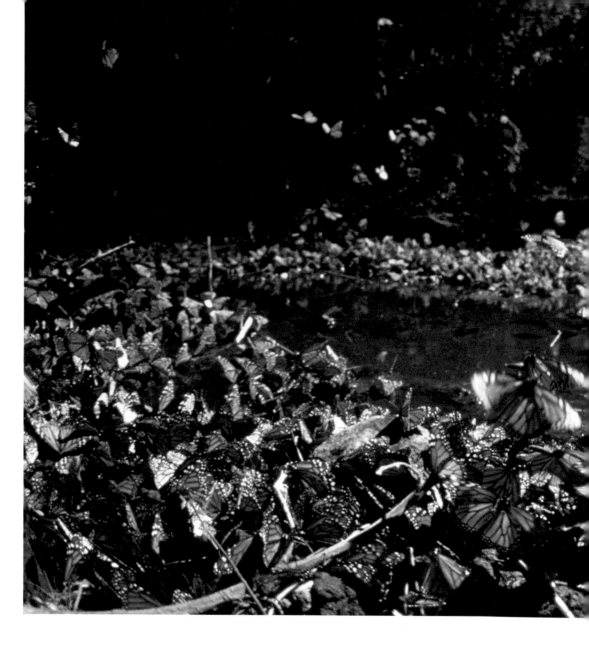

Spring comes early to the Sierra Madre Mountains, bringing with it the development of the females' reproductive organs and the cue to migrate once again. On warm, sunny days in January, the monarchs cluster at streams and marshy areas to drink water, a sign that they are ready to mate and head north. The females store sperm from the males, then fly off, laying fertilized eggs on milkweed plants along their route north. In about three days these eggs hatch; the adult butterflies that finally emerge also head north.

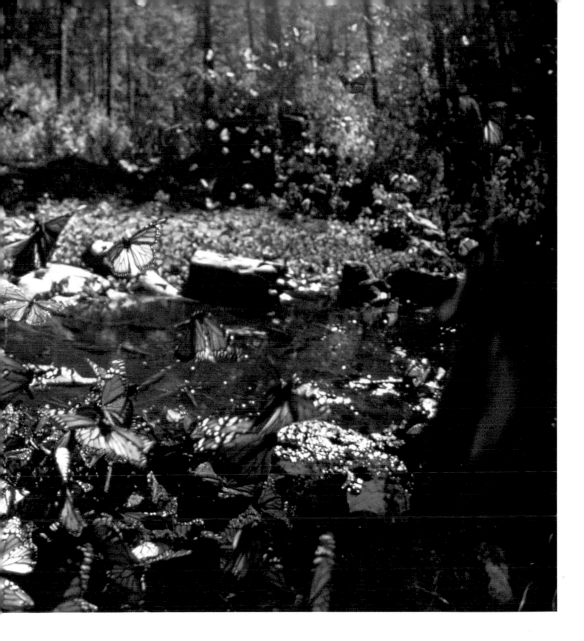

In May or early June, hardy migrant females reach the very same areas where they first nibbled milkweed leaves as caterpillars. Here they lay their last eggs, bringing to a close the eight to ten months of their migrant lives. But soon they are followed by their offspring, busily dotting the landscape with their own eggs. This generation and its offspring live only a month, however. By the end of August and early September, three or four generations are in the more northern breeding regions. Then shorter days and cooler temperatures cue the last generation. It is time to migrate. The cycle begins again.

Discovery of the Mexican overwintering grounds is considered the most important development in the study of monarch butterflies in the twentieth century. It was hoped the sites could be kept secluded, but thousands of tourists flocked to visit them. Now sanctuaries are being created by cooperating governments and wildlife groups. Logging also threatens the forest havens, however.

Elsewhere, other conditions endanger the monarchs. Herbicides are killing milkweed plants in monarchs' summer habitats and along their migration routes. Real-estate development encroaches on many of their roosting sites. Only time will tell whether or not we care enough to help the monarch butterfly ensure the survival of its species.

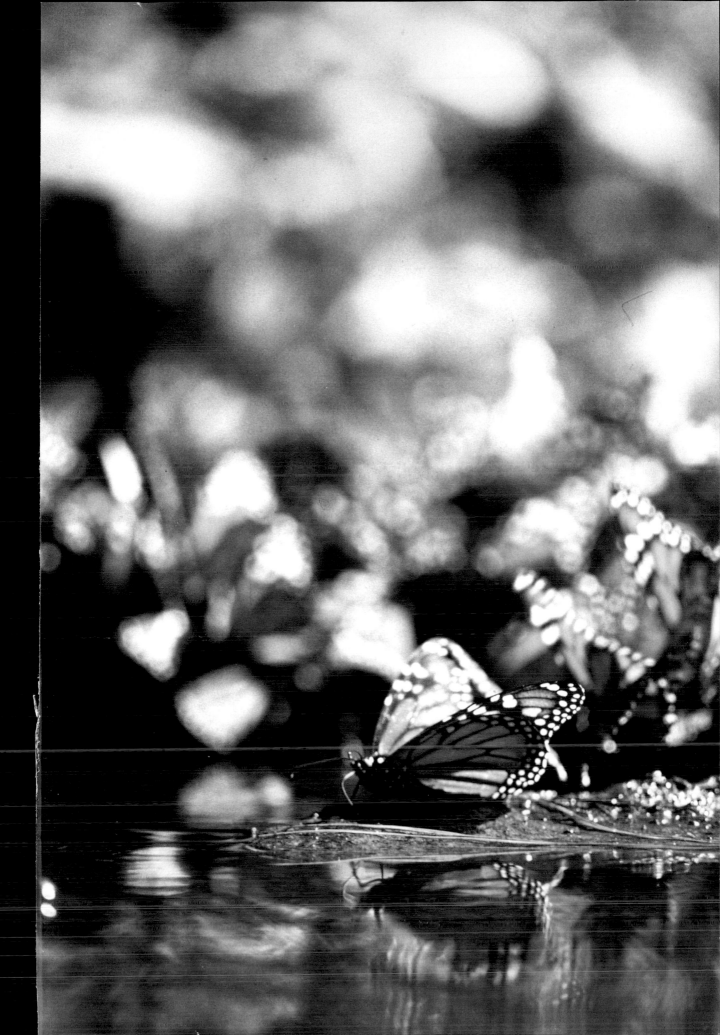

**Bianca Lavies** feels that being part of the expedition that led the Urquharts to the monarch overwintering sites in the Sierra Madre Mountains was a highlight of her eighteen-year career with *National Geographic*. "It was a great honor to witness the very emotional moment when the Urquharts saw the realization of their life's work for the first time," she says. "But it was not until fifteen days later that I felt that I had my best photographic day.

"After our usual midmorning snack of potatoes baked in the fire, we scrambled down a steep hill (eight minutes down, one hour up!) to a small mountain stream. It was a warm, sunny day, so the monarchs were very active. Many fluttered in the sky. Others crowded together in large colorful patches along the stream's muddy edges. They pushed each other, competing for more space and dipping their proboscises in the mud to quench their thirst. I worked frantically to keep up with the light, which moved rapidly across the water as the sun came and went behind the trees. I worked on low angles, squatting with my knees in the ice-cold water, ripping my pants on the rocks, slithering like a snake over the ground, covering my white T-shirt with mud. I kept seeing new angles and felt very excited.

"When I stepped back, I noticed magnificent reflections of monarchs crowding the edge of the water, their translucent wings backlit a bright orange as the sun shone through. I worked till I was sure I had captured this spectacular sight, then packed my cameras and climbed up to Cathy and Ken, who had been busy tagging.

"Cathy laughed when she saw the mud, the ripped pants, the dirty streaks of perspiration running down my face. 'You look like a little pig,' she said.

"But I didn't care. I would not have missed it for anything."